Erase Me Not!

A How to Draw for Kids

Copyright 2016

All Rights reserved. No part of this book may be reproduced or used in any way or formor by any means whether electronic or mechanical, this means that you cannot recordor photocopy any material ideas or tips that are provided in this book.

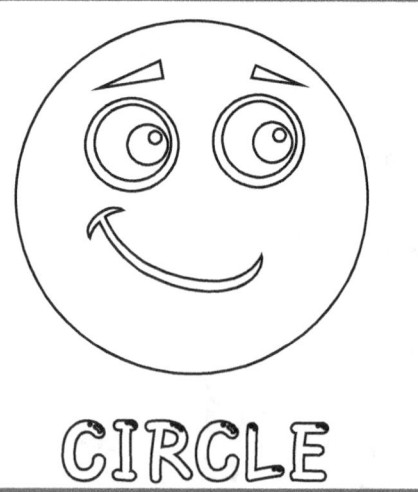
CIRCLE

DRAW
THE IMAGE

This is a Bleed Through Page If You Are Using a Coloring Marker or Pen!
Find Other Great Titles By searching for Activity Attic Books on Your Favorite Book Retailer
Amazon.Com | Barnes & Noble (BN.Com) | Books A Million (BAM.Com)

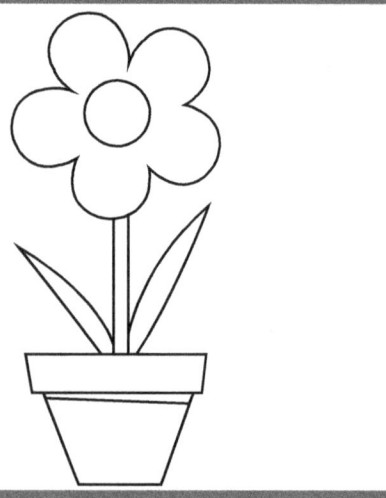

DRAW
THE IMAGE

This is a Bleed Through Page If You Are Using a Coloring Marker or Pen!
Find Other Great Titles By searching for *Activity Attic Books* on Your Favorite Book Retailer
Amazon.Com | Barnes & Noble (BN.Com) | Books A Million (BAM.Com)

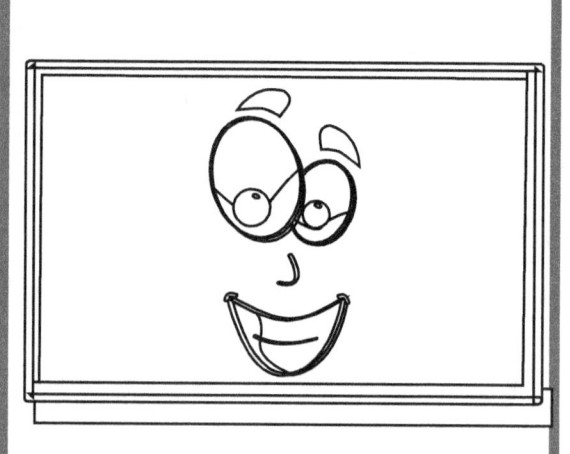

DRAW
THE
IMAGE

This is a Bleed Through Page If You Are Using a Coloring Marker or Pen!
Find Other Great Titles By searching for Activity Attic Books on Your Favorite Book Retailer
Amazon.Com | Barnes & Noble (BN.Com) | Books A Million (BAM.Com)

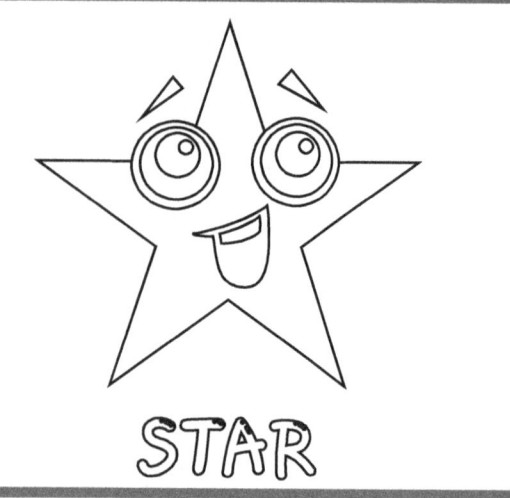

STAR

DRAW
THE
IMAGE

This is a Bleed Through Page If You Are Using a Coloring Marker or Pen!
Find Other Great Titles By searching for Activity Attic Books on Your Favorite Book Retailer
Amazon.Com | Barnes & Noble (BN.Com) | Books A Million (BAM.Com)

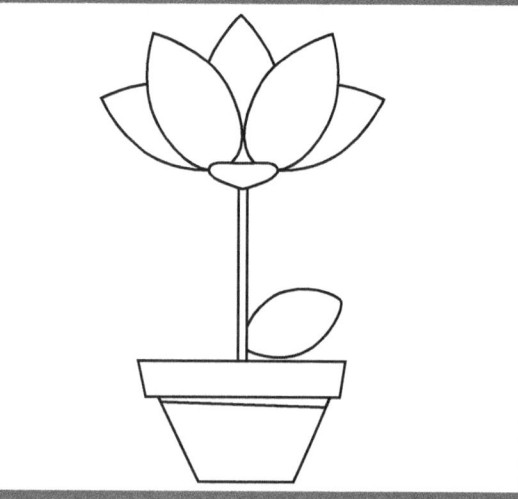

DRAW
THE
IMAGE

This is a Bleed Through Page If You Are Using a Coloring Marker or Pen!
Find Other Great Titles By searching for Activity Attic Books on Your Favorite Book Retailer
Amazon.Com | Barnes & Noble (BN.Com) | Books A Million (BAM.Com)

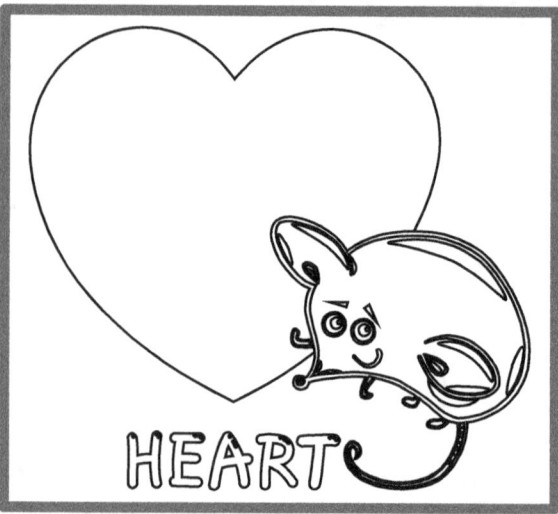

DRAW
THE
IMAGE

This is a Bleed Through Page If You Are Using a Coloring Marker or Pen!
Find Other Great Titles By searching for Activity Attic Books on Your Favorite Book Retailer
Amazon.Com | Barnes & Noble (BN.Com) | Books A Million (BAM.Com)

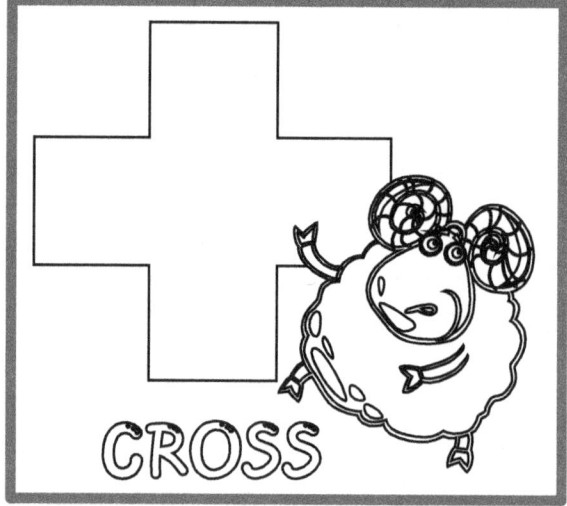

CROSS

DRAW
THE
IMAGE

This is a Bleed Through Page If You Are Using a Coloring Marker or Pen!
Find Other Great Titles By searching for *Activity Attic Books* on Your Favorite Book Retailer
Amazon.Com | Barnes & Noble (BN.Com) | Books A Million (BAM.Com)

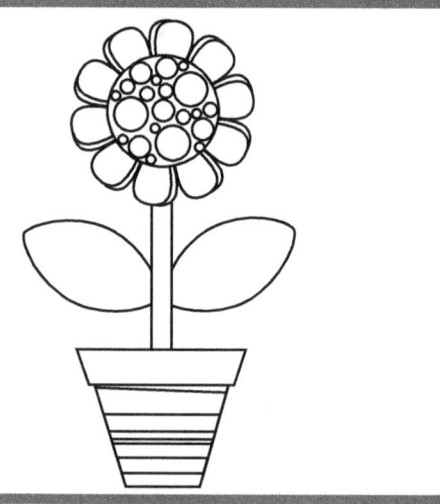

DRAW
THE
IMAGE

This is a Bleed Through Page If You Are Using a Coloring Marker or Pen!
Find Other Great Titles By searching for Activity Attic Books on Your Favorite Book Retailer
Amazon.Com | Barnes & Noble (BN.Com) | Books A Million (BAM.Com)

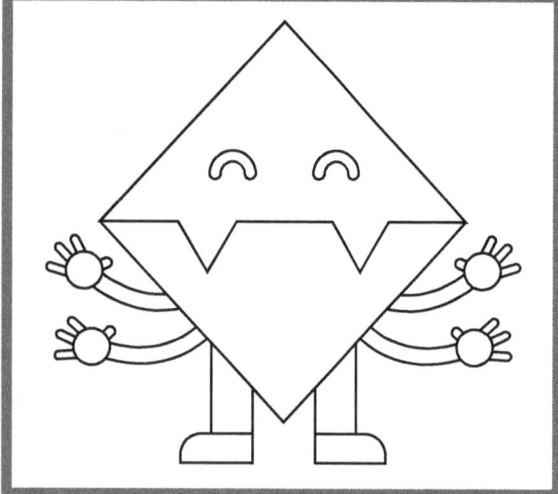

DRAW
THE
IMAGE

This is a Bleed Through Page If You Are Using a Coloring Marker or Pen!
Find Other Great Titles By searching for Activity Attic Books on Your Favorite Book Retailer
Amazon.Com | Barnes & Noble (BN.Com) | Books A Million (BAM.Com)

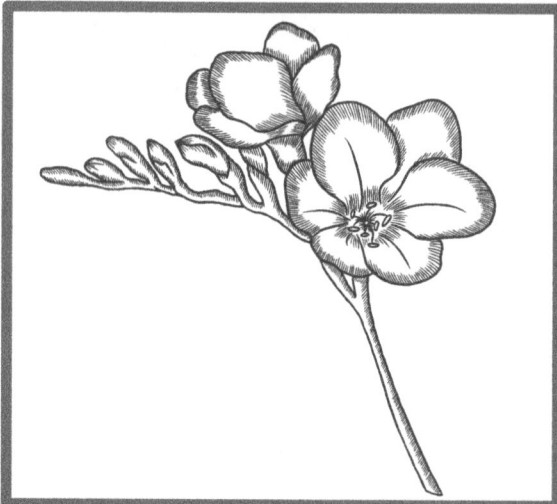

DRAW
THE
IMAGE

This is a Bleed Through Page If You Are Using a Coloring Marker or Pen!
Find Other Great Titles By searching for Activity Attic Books on Your Favorite Book Retailer
Amazon.Com | Barnes & Noble (BN.Com) | Books A Million (BAM.Com)

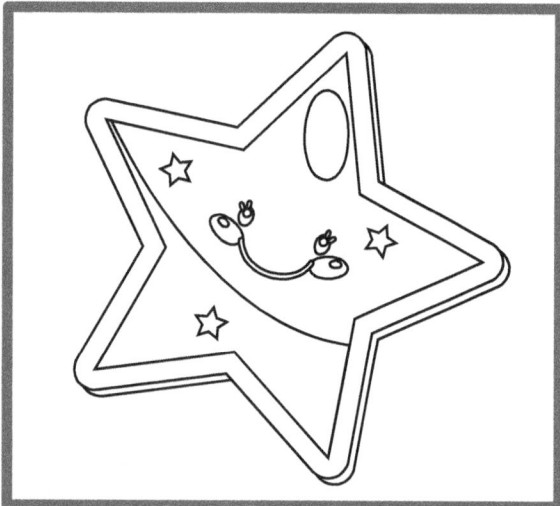

DRAW
THE
IMAGE

This is a Bleed Through Page If You Are Using a Coloring Marker or Pen!
Find Other Great Titles By searching for Activity Attic Books on Your Favorite Book Retailer
Amazon.Com | Barnes & Noble (BN.Com) | Books A Million (BAM.Com)

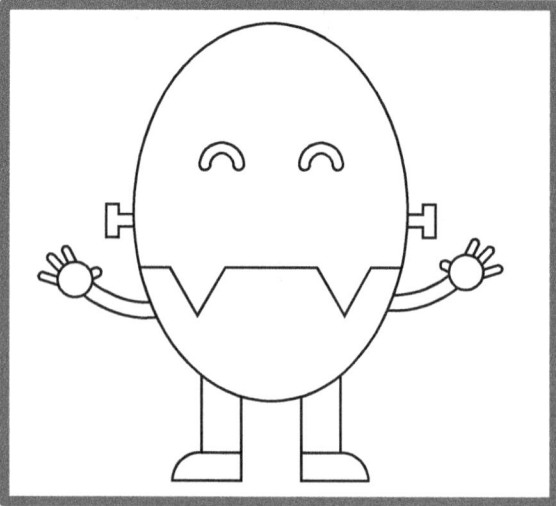

DRAW
THE
IMAGE

This is a Bleed Through Page If You Are Using a Coloring Marker or Pen!
Find Other Great Titles By searching for Activity Attic Books on Your Favorite Book Retailer
Amazon.Com | Barnes & Noble (BN.Com) | Books A Million (BAM.Com)

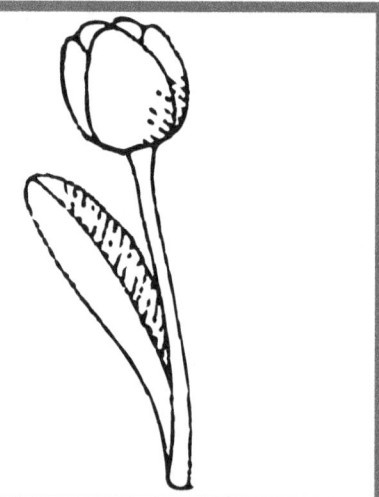

DRAW
THE
IMAGE

This is a Bleed Through Page If You Are Using a Coloring Marker or Pen!
Find Other Great Titles By searching for Activity Attic Books on Your Favorite Book Retailer
Amazon.Com | Barnes & Noble (BN.Com) | Books A Million (BAM.Com)

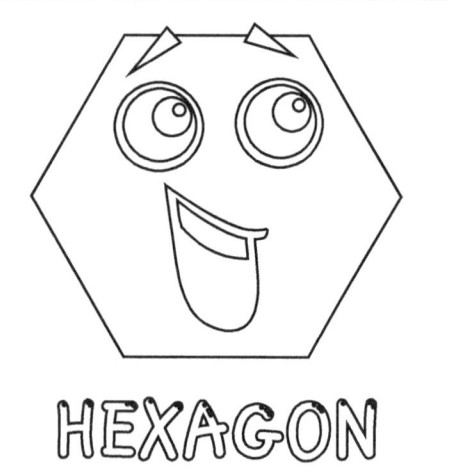

HEXAGON

DRAW
THE
IMAGE

This is a Bleed Through Page If You Are Using a Coloring Marker or Pen!
Find Other Great Titles By searching for Activity Attic Books on Your Favorite Book Retailer
Amazon.Com | Barnes & Noble (BN.Com) | Books A Million (BAM.Com)

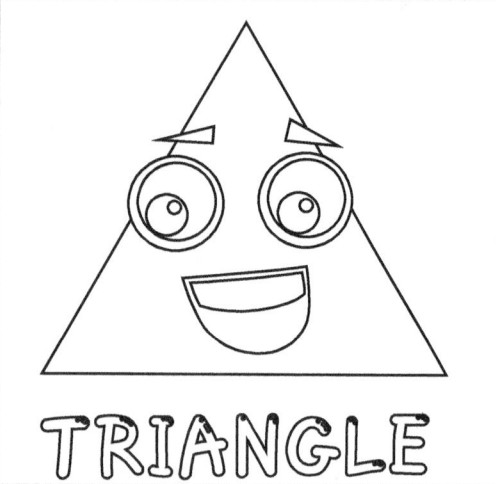

DRAW
THE
IMAGE

This is a Bleed Through Page If You Are Using a Coloring Marker or Pen!
Find Other Great Titles By searching for Activity Attic Books on Your Favorite Book Retailer
Amazon.Com | Barnes & Noble (BN.Com) | Books A Million (BAM.Com)

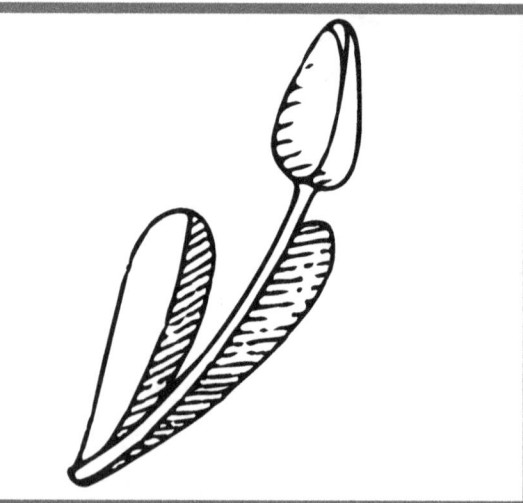

DRAW
THE
IMAGE

This is a Bleed Through Page If You Are Using a Coloring Marker or Pen!
Find Other Great Titles By searching for Activity Attic Books on Your Favorite Book Retailer
Amazon.Com | Barnes & Noble (BN.Com) | Books A Million (BAM.Com)

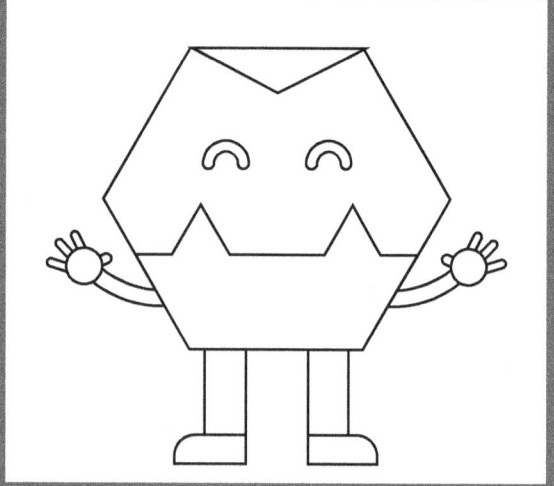

DRAW
THE
IMAGE

This is a Bleed Through Page If You Are Using a Coloring Marker or Pen!
Find Other Great Titles By searching for Activity Attic Books on Your Favorite Book Retailer
Amazon.Com | Barnes & Noble (BN.Com) | Books A Million (BAM.Com)

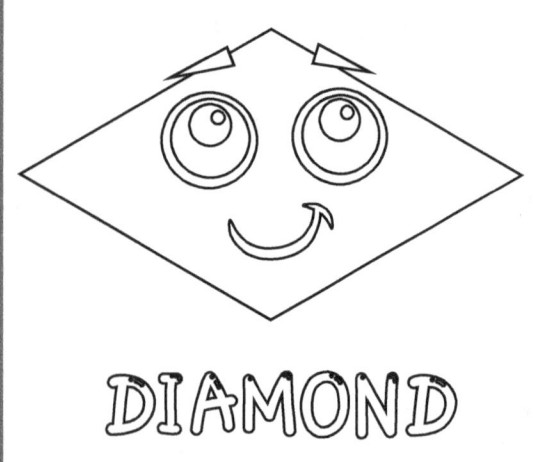

DIAMOND

DRAW
THE
IMAGE

This is a Bleed Through Page If You Are Using a Coloring Marker or Pen!
Find Other Great Titles By searching for Activity Attic Books on Your Favorite Book Retailer
Amazon.Com | Barnes & Noble (BN.Com) | Books A Million (BAM.Com)

DRAW
THE
IMAGE

This is a Bleed Through Page If You Are Using a Coloring Marker or Pen!
Find Other Great Titles By searching for Activity Attic Books on Your Favorite Book Retailer
Amazon.Com | Barnes & Noble (BN.Com) | Books A Million (BAM.Com)

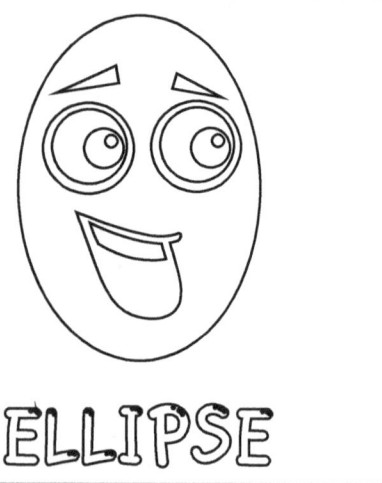

ELLIPSE

DRAW
THE
IMAGE

This is a Bleed Through Page If You Are Using a Coloring Marker or Pen!
Find Other Great Titles By searching for Activity Attic Books on Your Favorite Book Retailer
Amazon.Com | Barnes & Noble (BN.Com) | Books A Million (BAM.Com)

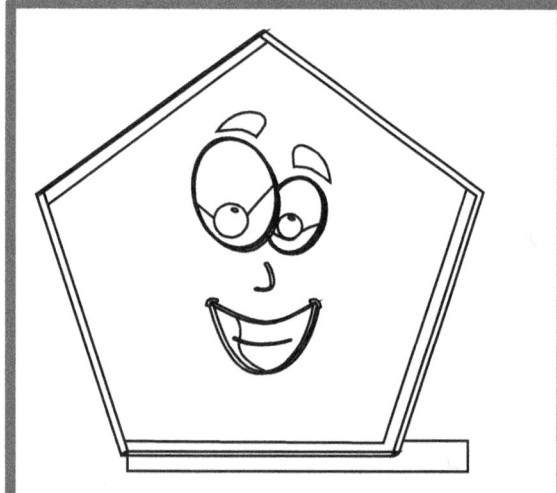

DRAW
THE
IMAGE

This is a Bleed Through Page If You Are Using a Coloring Marker or Pen!
Find Other Great Titles By searching for Activity Attic Books on Your Favorite Book Retailer
Amazon.Com | Barnes & Noble (BN.Com) | Books A Million (BAM.Com)

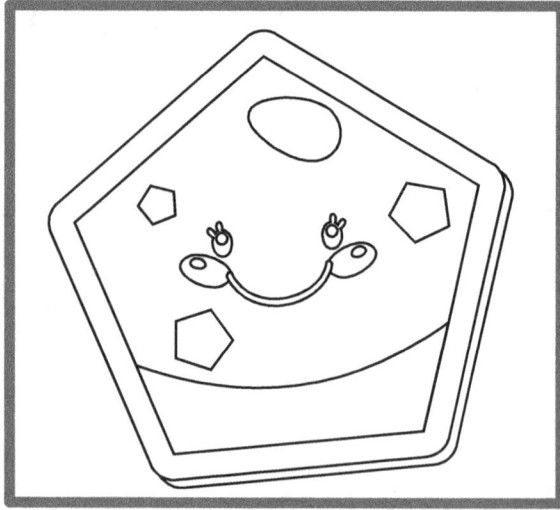

DRAW
THE IMAGE

This is a Bleed Through Page If You Are Using a Coloring Marker or Pen!
Find Other Great Titles By searching for Activity Attic Books on Your Favorite Book Retailer
Amazon.Com | Barnes & Noble (BN.Com) | Books A Million (BAM.Com)

DRAW
THE
IMAGE

This is a Bleed Through Page If You Are Using a Coloring Marker or Pen!
Find Other Great Titles By searching for Activity Attic Books *on Your Favorite Book Retailer*
Amazon.Com | Barnes & Noble (BN.Com) | Books A Million (BAM.Com)

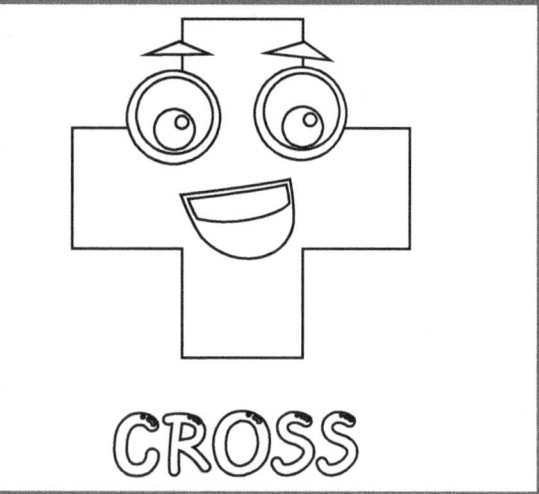

CROSS

DRAW
THE
IMAGE

This is a Bleed Through Page If You Are Using a Coloring Marker or Pen!
Find Other Great Titles By searching for Activity Attic Books on Your Favorite Book Retailer
Amazon.Com | Barnes & Noble (BN.Com) | Books A Million (BAM.Com)

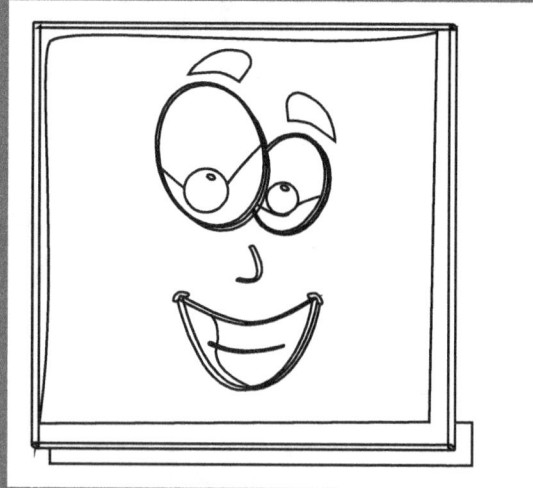

DRAW
THE
IMAGE

This is a Bleed Through Page If You Are Using a Coloring Marker or Pen!
Find Other Great Titles By searching for Activity Attic Books on Your Favorite Book Retailer
Amazon.Com | Barnes & Noble (BN.Com) | Books A Million (BAM.Com)

DRAW
THE
IMAGE

This is a Bleed Through Page If You Are Using a Coloring Marker or Pen!
Find Other Great Titles By searching for Activity Attic Books on Your Favorite Book Retailer
Amazon.Com | Barnes & Noble (BN.Com) | Books A Million (BAM.Com)

DRAW
THE
IMAGE

This is a Bleed Through Page If You Are Using a Coloring Marker or Pen!
Find Other Great Titles By searching for Activity Attic Books on Your Favorite Book Retailer
Amazon.Com | Barnes & Noble (BN.Com) | Books A Million (BAM.Com)

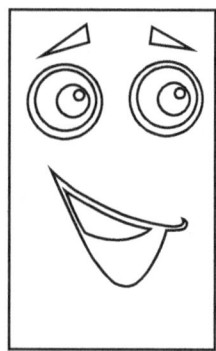

RECTANGLE

DRAW
THE
IMAGE

This is a Bleed Through Page If You Are Using a Coloring Marker or Pen!
Find Other Great Titles By searching for Activity Attic Books on Your Favorite Book Retailer
Amazon.Com | Barnes & Noble (BN.Com) | Books A Million (BAM.Com)

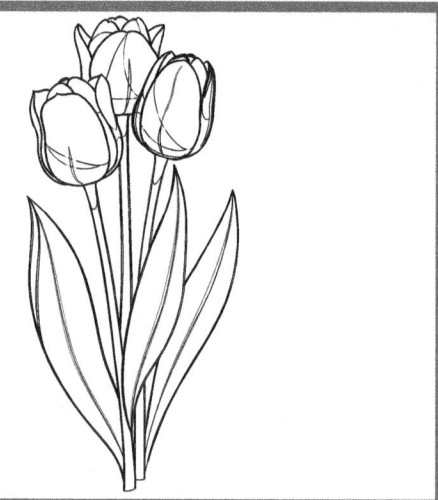

DRAW
THE
IMAGE

This is a Bleed Through Page If You Are Using a Coloring Marker or Pen!
Find Other Great Titles By searching for Activity Attic Books on Your Favorite Book Retailer
Amazon.Com | Barnes & Noble (BN.Com) | Books A Million (BAM.Com)

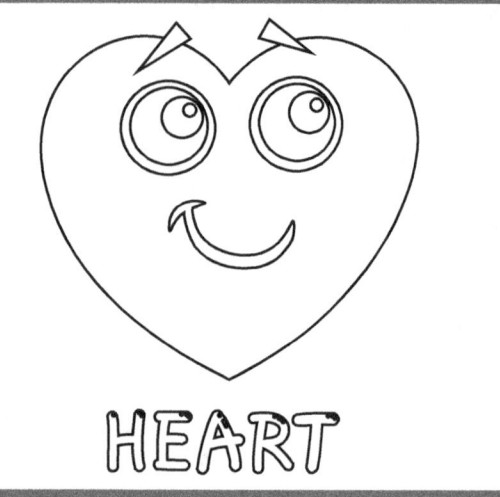
HEART

DRAW
THE
IMAGE

This is a Bleed Through Page If You Are Using a Coloring Marker or Pen!
Find Other Great Titles By searching for Activity Attic Books on Your Favorite Book Retailer
Amazon.Com | Barnes & Noble (BN.Com) | Books A Million (BAM.Com)

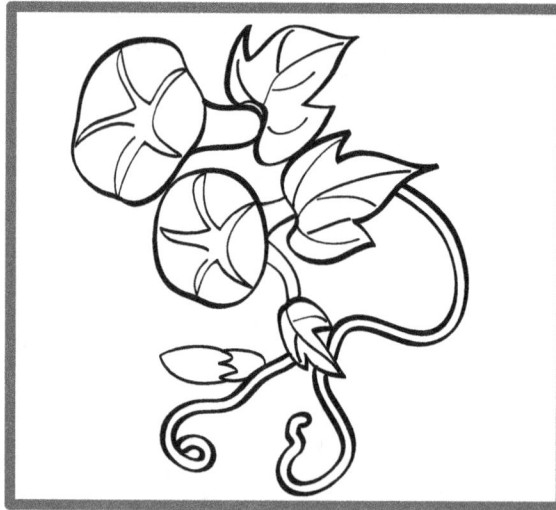

DRAW
THE
IMAGE

This is a Bleed Through Page If You Are Using a Coloring Marker or Pen!
Find Other Great Titles By searching for Activity Attic Books on Your Favorite Book Retailer
Amazon.Com | Barnes & Noble (BN.Com) | Books A Million (BAM.Com)

DRAW
THE
IMAGE

This is a Bleed Through Page If You Are Using a Coloring Marker or Pen!
Find Other Great Titles By searching for Activity Attic Books on Your Favorite Book Retailer
Amazon.Com | Barnes & Noble (BN.Com) | Books A Million (BAM.Com)

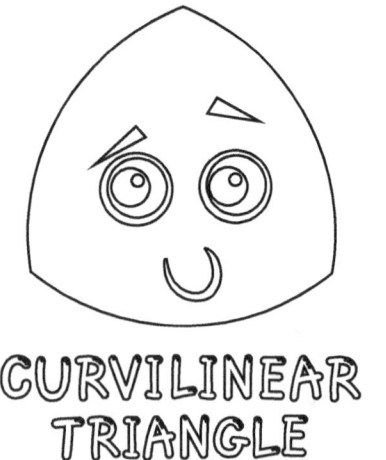
CURVILINEAR TRIANGLE

DRAW
THE IMAGE

This is a Bleed Through Page If You Are Using a Coloring Marker or Pen!
Find Other Great Titles By searching for Activity Attic Books on Your Favorite Book Retailer
Amazon.Com | Barnes & Noble (BN.Com) | Books A Million (BAM.Com)

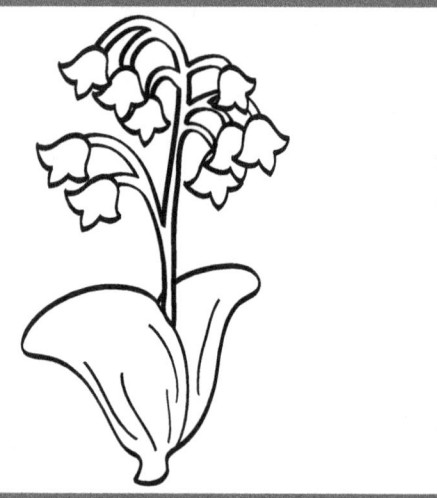

DRAW
THE
IMAGE

This is a Bleed Through Page If You Are Using a Coloring Marker or Pen!
Find Other Great Titles By searching for Activity Attic Books on Your Favorite Book Retailer
Amazon.Com | Barnes & Noble (BN.Com) | Books A Million (BAM.Com)

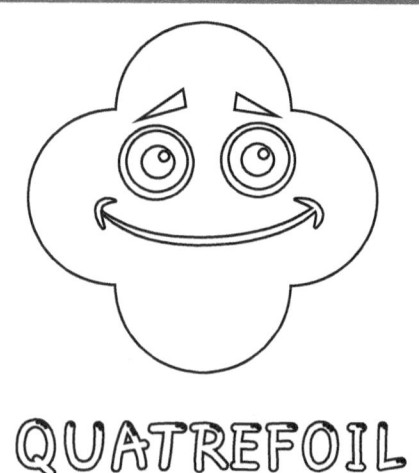

QUATREFOIL

DRAW
THE
IMAGE

This is a Bleed Through Page If You Are Using a Coloring Marker or Pen!
Find Other Great Titles By searching for Activity Attic Books on Your Favorite Book Retailer
Amazon.Com | Barnes & Noble (BN.Com) | Books A Million (BAM.Com)

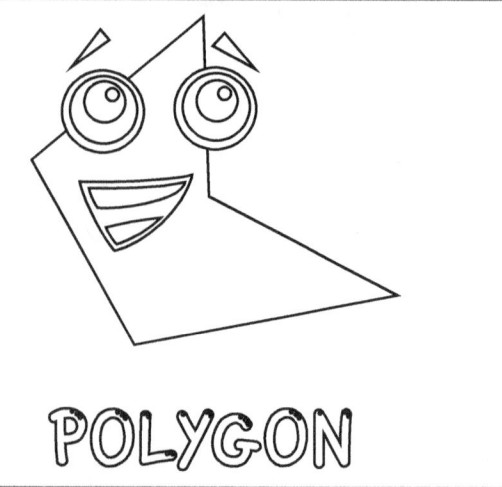

POLYGON

DRAW
THE
IMAGE

This is a Bleed Through Page If You Are Using a Coloring Marker or Pen!
Find Other Great Titles By searching for Activity Attic Books on Your Favorite Book Retailer
Amazon.Com | Barnes & Noble (BN.Com) | Books A Million (BAM.Com)

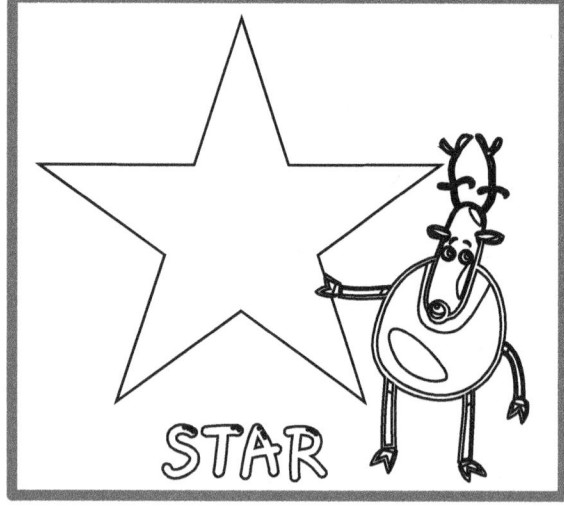

DRAW
THE
IMAGE

This is a Bleed Through Page If You Are Using a Coloring Marker or Pen!
Find Other Great Titles By searching for Activity Attic Books on Your Favorite Book Retailer
Amazon.Com | Barnes & Noble (BN.Com) | Books A Million (BAM.Com)

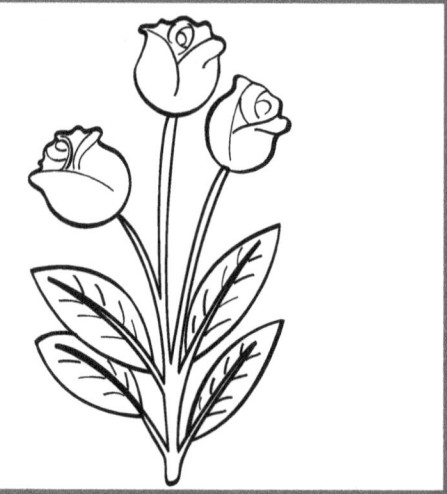

DRAW
THE
IMAGE

This is a Bleed Through Page If You Are Using a Coloring Marker or Pen!
Find Other Great Titles By searching for Activity Attic Books *on Your Favorite Book Retailer*
Amazon.Com | Barnes & Noble (BN.Com) | Books A Million (BAM.Com)

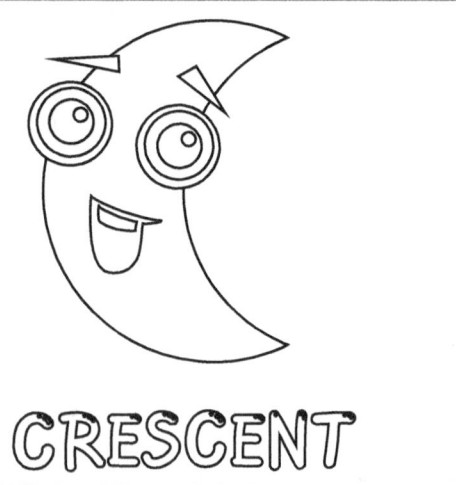

CRESCENT

DRAW
THE
IMAGE

This is a Bleed Through Page If You Are Using a Coloring Marker or Pen!
Find Other Great Titles By searching for Activity Attic Books on Your Favorite Book Retailer
Amazon.Com | Barnes & Noble (BN.Com) | Books A Million (BAM.Com)

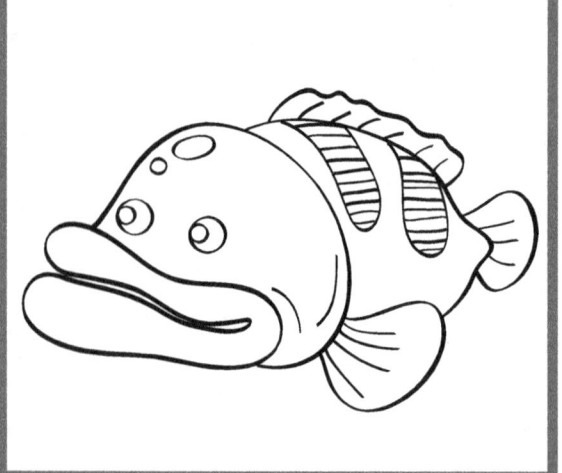

DRAW
THE
IMAGE

This is a Bleed Through Page If You Are Using a Coloring Marker or Pen!
Find Other Great Titles By searching for Activity Attic Books on Your Favorite Book Retailer
Amazon.Com | Barnes & Noble (BN.Com) | Books A Million (BAM.Com)

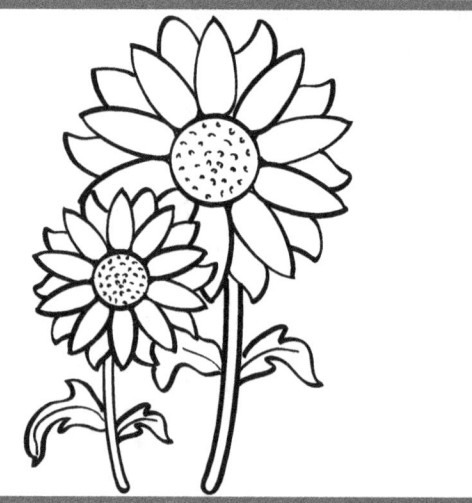

DRAW
THE
IMAGE

This is a Bleed Through Page If You Are Using a Coloring Marker or Pen!
Find Other Great Titles By searching for Activity Attic Books on Your Favorite Book Retailer
Amazon.Com | Barnes & Noble (BN.Com) | Books A Million (BAM.Com)

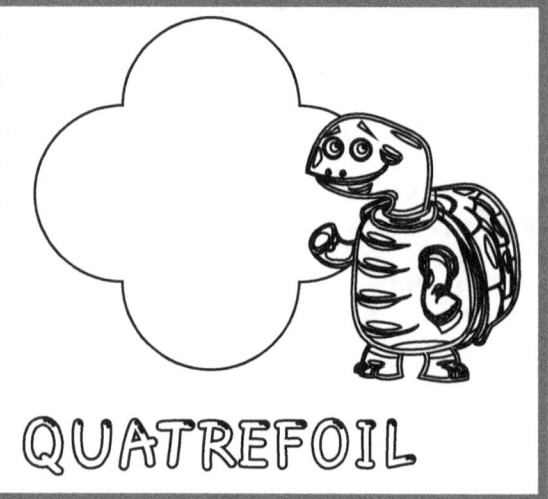

QUATREFOIL

DRAW
THE
IMAGE

This is a Bleed Through Page If You Are Using a Coloring Marker or Pen!
Find Other Great Titles By searching for Activity Attic Books on Your Favorite Book Retailer
Amazon.Com | Barnes & Noble (BN.Com) | Books A Million (BAM.Com)

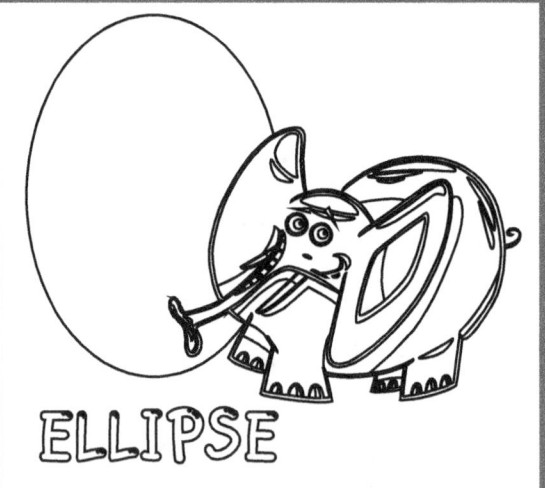

ELLIPSE

DRAW
THE
IMAGE

This is a Bleed Through Page If You Are Using a Coloring Marker or Pen!
Find Other Great Titles By searching for Activity Attic Books on Your Favorite Book Retailer
Amazon.Com | Barnes & Noble (BN.Com) | Books A Million (BAM.Com)

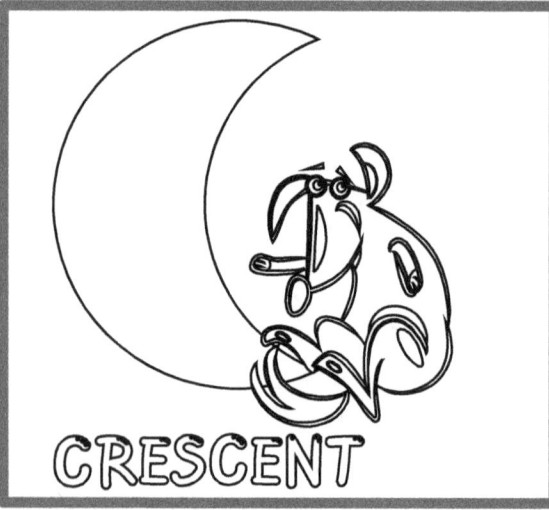

DRAW THE IMAGE

This is a Bleed Through Page If You Are Using a Coloring Marker or Pen!
Find Other Great Titles By searching for Activity Attic Books on Your Favorite Book Retailer
Amazon.Com | Barnes & Noble (BN.Com) | Books A Million (BAM.Com)

DRAW
THE
IMAGE

This is a Bleed Through Page If You Are Using a Coloring Marker or Pen!
Find Other Great Titles By searching for Activity Attic Books on Your Favorite Book Retailer
Amazon.Com | Barnes & Noble (BN.Com) | Books A Million (BAM.Com)

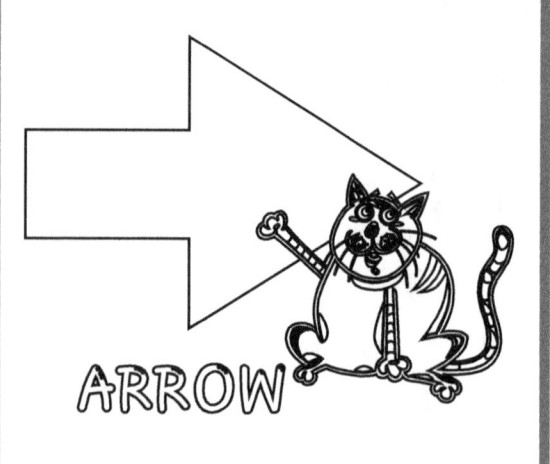

DRAW
THE
IMAGE

This is a Bleed Through Page If You Are Using a Coloring Marker or Pen!
Find Other Great Titles By searching for Activity Attic Books on Your Favorite Book Retailer
Amazon.Com | Barnes & Noble (BN.Com) | Books A Million (BAM.Com)

SQUARE

DRAW
THE
IMAGE

This is a Bleed Through Page If You Are Using a Coloring Marker or Pen!
Find Other Great Titles By searching for Activity Attic Books on Your Favorite Book Retailer
Amazon.Com | Barnes & Noble (BN.Com) | Books A Million (BAM.Com)

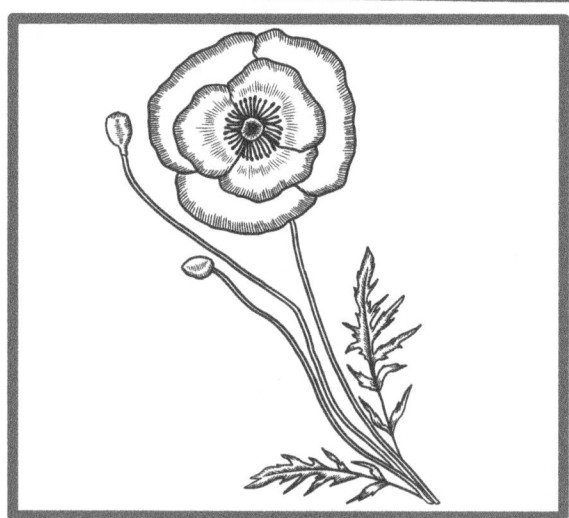

DRAW
THE
IMAGE

This is a Bleed Through Page If You Are Using a Coloring Marker or Pen!
Find Other Great Titles By searching for Activity Attic Books on Your Favorite Book Retailer
Amazon.Com | Barnes & Noble (BN.Com) | Books A Million (BAM.Com)

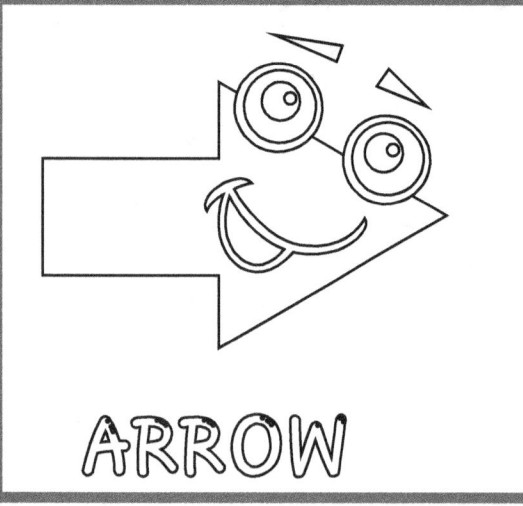

ARROW

DRAW
THE
IMAGE

This is a Bleed Through Page If You Are Using a Coloring Marker or Pen!
Find Other Great Titles By searching for Activity Attic Books on Your Favorite Book Retailer
Amazon.Com | Barnes & Noble (BN.Com) | Books A Million (BAM.Com)

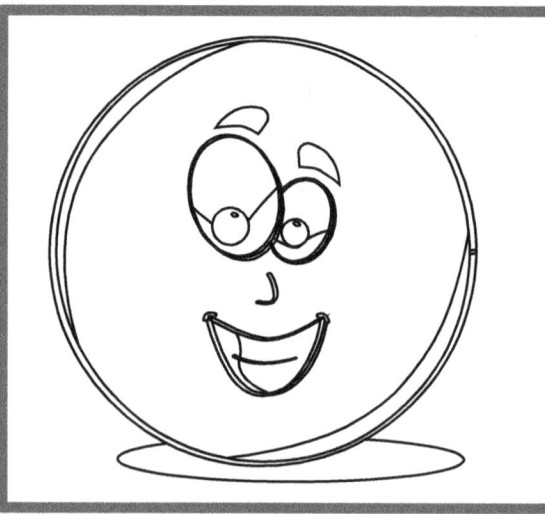

DRAW
THE
IMAGE

This is a Bleed Through Page If You Are Using a Coloring Marker or Pen!
Find Other Great Titles By searching for Activity Attic Books on Your Favorite Book Retailer
Amazon.Com | Barnes & Noble (BN.Com) | Books A Million (BAM.Com)

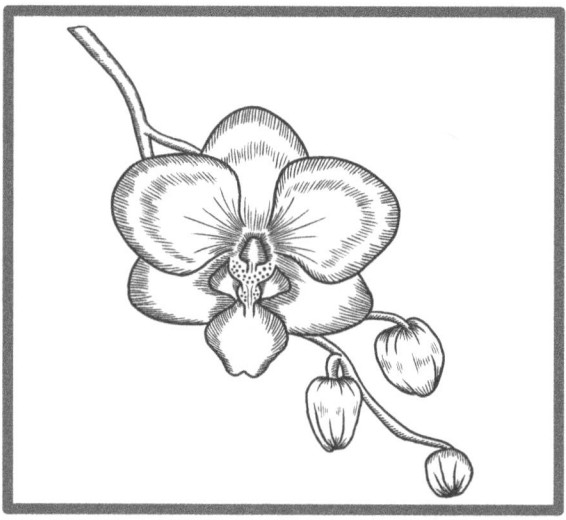

DRAW
THE
IMAGE

This is a Bleed Through Page If You Are Using a Coloring Marker or Pen!
Find Other Great Titles By searching for Activity Attic Books on Your Favorite Book Retailer
Amazon.Com | Barnes & Noble (BN.Com) | Books A Million (BAM.Com)

DRAW THE IMAGE

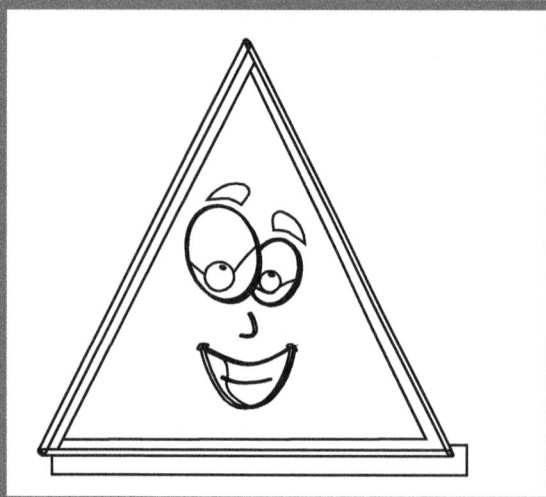

This is a Bleed Through Page If You Are Using a Coloring Marker or Pen!
Find Other Great Titles By searching for Activity Attic Books on Your Favorite Book Retailer
Amazon.Com | Barnes & Noble (BN.Com) | Books A Million (BAM.Com)